How To Write a Bestseller

The Secret Formula

A Formulaic Creative Writing Course for Book, Stage, Television and Film

By

Neil A. Clark

In memory of my mate

Rosemarie Elizabeth Donahue

Goodnight Sweetheart

First published by Cottage Publishing 2006
ISBN 0-9553257-0-6 ISBN 978-0-9553257-0-0

Kindle version © celtworld.co.uk February 2011

Revised and extended paperback edition published by
Celtworld.co.uk December 2015 - © celtworld.co.uk
ISBN 978-1-326-49339-4

Typesetting by Celtworld.co.uk Kindle and Paper-book Design Services

Copyright Notice

Copying and redistribution of the information and images in this document, in any form or any part, is strictly prohibited. Further copies are available from www.celtworld.co.uk, www.amazon.com, CreateSpace eStore and CreateSpace Direct.

No changes to the book or electronic file, or reuse in part or in whole, other than for personal use, shall be permitted without the prior consent of the copyright holder.

Contents

Introduction	5
Wig or Cap Components	9
A Formulaic Example Story	17
Handling Multiple Plots	23
Simple Stories	25
Getting Creative	29
Essays and Reports	35
Example 1 – Children's Story	39
Example 2 – Comedy Film	43

An Introduction to the Wig Or Cap Method

Having a way with words may be necessary to capture the attention of your audience, but creating a solid and well thought out plot is the secret to keeping them interested enough to stay to the end.

The 'Wig Or Cap' story is not intended to offer an example of writing style, content or presentation. Rather, it is the objective of the author to provide a simple formula which, if adhered to, will ensure that your own work conforms to the classic rules of story telling and creates a compelling tale for it's audience.

This approach leaves the author entirely unencumbered by the typical creative restraints that other writing methods generally impose. Followers of the method outlined in this guide will therefore be free to exercise all the poetic licence and individuality of style that they wish to express in their work.

The example story has been designed to be both simple to follow and easy to remember, because the first letters of each section spell out the words, 'Wig Or Cap'. This ensures that, once mastered, you will be able to put this simple and unique writing method into practice without the necessity to continually refer back to the original text.

So how does this structure work you might ask. According to common practice, almost all stories can be divided into three Acts, a beginning, middle and an end if you like. The 'Wig Or Cap' method breaks down these three components to make it easy to understand their purpose, and in consequence it is very easy to apply it to your own stories.

One of the interesting things about the Wig Or Cap method is that it is not only applicable to the whole

story, but is equally effective when applied to subsections of longer works. Individual chapters, episodes or even short sections within these elements can all benefit from the application of this formulaic approach.

It is not always easy to remember this, but if you suddenly find that you have developed a block while writing a particular section of your story, simply re-organise the structure of the problematic section, in accordance with the Wig Or Cap formula, and you will soon be underway again.

And as a final note of encouragement, good Luck with your next bestseller!

Wig or Cap Components

ACT I

World

The first purpose of Act I is to describe the 'World' in which the story takes place and introduce the initial characters, almost always including the hero or the heroin, of which there may be more than one.

The audience clearly require an introduction to the world of your characters, but how quickly that image is built will depend on you. The world can be essentially revealed rapidly in just a few sentences for particular effect, or more commonly, slowly over the course of Act I.

Imbalance

The 'imbalance' is an action or occurrence that upsets the harmony of normal life for one or more inhabitants of the 'World'. It is usually caused by a deliberate and negative action and so offers a convenient place to introduce the villain of the tale. In children's stories in particular, the imbalance may seem to be positive, for example the discovery of a magic apple, but may lead to something negative, such as leaving home without informing anyone.

Goal

The introduction of the 'Imbalance' provides the catalyst for a 'Goal' to be devised. Together the 'Imbalance' and the 'Goal' provide an opportunity to introduce a moral to the tale, if a moral is required.

Usually the 'Goal' will be a quest to restore the balance of life in the 'World', perhaps to right a wrong, or improve the lot of the inhabitants. Sometimes the 'Goal' is reluctantly undertaken.

ACT II

It is not uncommon for Act II to introduce a secondary world, affiliated to the first world of Act I but essentially extending it beyond the boundaries previously revealed.

A typical situation where this idea is commonly applied might be created when the protagonist embarks on a journey into the domain of the villain, in order to pursue the Goal. For example, the hero may venture forth into the mountains to seek and destroy an evil dragon, which has been periodically eating the children of the village below. The detail of the domain of the villain, in this case the Dragon, must be provided as this second world gradually becomes amalgamated into the first.

While it should remembered that Act II will often require the continuation of the development of the World, the primary purpose of the second act is to extend the story; by depicting the struggle to achieve the Goal using two simple and distinct elements, the 'Obstacle' and the 'Resolution'.

Obstacle

The 'Obstacle' is a problem encountered during the attempt by the protagonist to achieve the 'Goal'. For example, in the scenario described above, the would-be hero may have been advised to collect a special sword that has been secreted deep within a cave on route to the Dragon's lair. However, upon arriving at the cave, the hero discovers that a vicious viper of enormous proportions guards the entrance and he is powerless to enter.

Resolution

In order for the story to move forwards, each 'Obstacle' must be met by a 'Resolution'. In the example above, the hero might resolve to camp outside the cave and consider his options. As night beings to fall, he notices that the sight of the full moon charms the snake into a trance like state. Now the intrepid champion takes a torch from the fire and, seizing his opportunity to sneak past the snake, he ventures forth into the darkness of the cave.

There can be as many 'Obstacles' and 'Resolutions' in Act II as the author might require. In many action films, Act II frequently consists of a string of obstacles and resolutions that collectively comprise by far the greater part of the production.

ACT III

Complication

The 'Complication' is rather like a final 'Obstacle', which often marks the opening of Act III by introducing an element of the unexpected. Perhaps, having finally commenced battle with the dragon, the magic sword is found to be completely ineffective against the iron like scales of the fearsome monster!

In the case of mysteries, the 'Complication' provides an opportunity to insert the missing piece of evidence into the puzzle, thereby providing the author with the facility to reveal the overall plot.

Attainment

During this section, the 'Goal' will be realised. This is not always as originally perceived, but invariably facilitates the restoration of balance and harmony to the 'World', and the realisation of any moral message.

Perhaps it is not the edge of the sword that the dragon fears, but its shiny surface, for when the dragon sees its reflection in the sword, it rears up and exposes its soft underbelly to the awaiting victor.

Parcel

Quite obviously, the 'Parcel' refers to the wrapping up of the story, and, particularly in the case of mysteries, includes the provision of explanations for any loose ends.

Here the wisdom of any moral realised by the 'Attainment' can be crystallised.

Hook

This is a purely optional extra and is generally used to set the stage for a sequel. The 'Hook' provides a reason for the story to continue, such as the escape of the Villain, the establishment of a new 'Goal' or the threat of a new 'Injustice'.

It is particularly important when writing television drama series, or can be extremely useful when applied to the ends of chapters in a novel.

The 'Hook' is the key to persuading the audience to return and is not solely used at the end of the 'Parcel'. Revealing the 'Goal' could be used as a hook before the commercial break in a television drama, by leaving the audience wondering if the would-be hero is going to take up the challenge and rescue the maiden for example.

If you place your 'Hooks' before the commercial break at the end of an episode, or on the last page of a chapter, your audience will be persuaded to return in order to discover what will become of the characters.

Wig Or Cap

The Formulaic Example Story

ACT I

World

Once upon a time, there was a man called Joe. Mr. Average his friends called him, and not without good reason.

Joe had an average job, lived in an average house and drove an average car, but one thing was not quite so average about Joe. He had a lot of debts.

Imbalance

Joe's dream was to win the lottery and pay off his debts, but when he wasn't dreaming he was worrying. Unable to keep pace with his worries, Joe eventually became so ill that he had to visit his doctor.

Joe's doctor could find nothing wrong with him and referred him to Nicholas Penny, a specialist at the local hospital. Nicholas was a charming, highly regarded man and immediately put Joe at his ease. He took several blood samples and told Joe not to worry.

When Joe went back for the results two days later, Dr. Penny had a solemn expression on his face. "Come in and take a seat Joe", he said, pushing a chair out as though he thought Joe might fall down at any moment. "I'm afraid I have some bad news for you."

Joe sat down and looked to Dr. Penny, terrified of the words that he knew were soon to follow.

"You have cancer."

Goal

Joe was shocked. He went home to consider the advice that Dr. Penny had given him. Either leave the cancer and suffer a long slow death, or embark upon a course of risky and unpleasant chemotherapy in an effort to fight the cancer.

Eventually Joe made his decision. Joe determined to get rid of his cancer.

ACT II

Obstacle

Unfortunately for Joe, embarking upon the treatment caused severe physical problems and, despite his courageous attitude, Joe's mental state worsened. His problems seemed to become wholly insurmountable when eventually his hair began to fall out.

In desperation he decided to return to Dr. Penny to see if anything could be done to alleviate his dire situation.

Resolution

Dr. Penny was very sympathetic and recommended that he visit Mr Chup, a friend of his who made wigs especially for people in Joe's situation. "They aren't cheap," he said, "but they are well worth the money for all the self-confidence that they restore."

Joe was very worried about the cost of the wig, but put on an old cap to cover his embarrassment and went to see Mr Chup anyway.

The waiting room was full of other people with caps on. He looked at them one at a time, studying the tufts of thin and wispy hair poking out from the edges of their ill-fitting caps.

Suddenly he realised that he had to make a decision, get a wig or keep the cap. Joe decided there and then, before going in for the fitting, what he was going to do. Joe was going to buy himself a wig.

ACT III

Complication

On return to Mr. Chup's premises to collect his wig, Joe noticed a Rolls Royce with the registration WIG 1, parked in the car park outside.

While he was waiting in the waiting room, Joe began to wonder how an ordinary wig maker could afford such an expensive car. He talked to some of the other people waiting with him and soon discovered that they too had been advised to see to Mr. Chup, by non other than Dr Penny.

Joe's suspicions were aroused. He began to wonder. "Might these two be working in league? Could it be possible that Dr Penny treated everyone who came to him with chemotherapy, regardless of whether they had cancer or not, in order to make money out of the wig trade?"

The more he thought about it, the more Joe became convinced that something was not right, and he determined to investigate further.

Attainment

After receiving his wig, Joe went straight to another hospital and requested a second opinion with regard to his cancer diagnosis. Sure enough, two days later, the hospital phoned to tell him that there was no trace of any cancer in his body.

Joe breathed a sigh of relief. His cancer was gone.

Parcel

The following day Joe contacted the police and told them the whole story. The investigation was very quick and the two villains were soon found guilty and sent to jail. No one would ever again be needlessly subjected to such a terrifying ordeal.

Joe's problems were completely solved when, one sunny morning a letter arrived containing a compensation cheque, large enough to pay off his debts and live happily ever after.

Multiple Plots

In some cases stories will require multiple plots that are to run alongside each other. An obvious example of this would be a detective novel where the hero is persuaded by a poor maiden in distress to take up her case with no promise of payment.

Here the stage is set for a dual plot, with a mystery to be solved and a romance to be nurtured.

The 'Wig Or Cap' method can be applied to both the mystery and the romance at the same time. Usually the individual elements of the formula will be applied to both plots concurrently, as the two will often be inextricably entwined.

Sometimes it will be beneficial to separate the two components, for example applying an Obstacle and a Resolution to the detective plot first, followed by an Obstacle and a Resolution for the romantic plot.

Simple Stories

In most cases, splitting a story line into the eight or nine logical sections of the 'Wig Or Cap' formula will simplify the task of devising a structure for your plot. But what do you do if eight or nine elements provide too complex a framework for your particular project?

Alternatively, you may find yourself struggling with a subsection of your work, too short for the implementation of the Wig Or Cap formula, but still wish to impart the benefits of formulaic approach.

The obvious way to simplify the plot structure would be to drop one or more of the elements of the formula. While this can work, the results are sometimes less than satisfactory.

Losing the Goal would have a disastrous effect on the readability of your text, and would probably cause your reader to close your book for good before actually reaching the end. There will seem little point in pursuing even the shortest of stories, if it appeared to be leading nowhere from the very outset.

Equally, failing to begin to outline your World would mean that the imagination of the reader would not be sufficiently sparked for them to take your book off the bookstand and put it in their basket.

In fact, a case can be made for the retention of every single element of the formula, because, with even one critical component missing the tried and tested magic of the formulaic approach will be broken. So what is the answer to this problem, if dropping elements of the formula is so inadvisable?

A far better outcome can be achieved by merging two or more elements at a time, perhaps by combining an 'Imbalance' and a 'Goal' into one element, and a 'Resolution' and an 'Attainment' into another. In this way a story, chapter or even sometimes a single paragraph, can be invigorated by the application of the formulaic approach, without the need to sacrifice a single element.

In the later chapter, *Examples in Use*, we are going to consider a children's book where this principle has been effectively applied. The word and picture storybook has just six pages, each containing one paragraph of no more than two sentences, yet the Wig Or Cap structure has still been successfully employed.

Getting Creative

While this book provides sound and reliable advice on creating a structure for almost any type of written work, it is not intended to teach you how to write creatively. This is an area that really requires individual tuition, as every writer will have different aspirations with respect to style.

If you need to hone your skills in this area it would be best to seek the assistance of a writer's group, or join a creative writing workshop, and then ask for the opinions and advice of others who have different ideas and experiences.

Having said that, there are a handful of important rules that, if adhered to closely enough, will go a long way to raising your chances of success.

Grab Your Audience

Try to catch the imagination of your audience from the very outset. Raise their curiosity with the first line if you can and continue to build an air of intrigue, mystery or suspense in the paragraphs that follow.

Unfold the World

Don't rush to describe your world, allow it to unfold as necessary, primarily during the course of Act I, and remember to give plenty of attention to establishing the 'character' of your characters.

Consider Dialogue Over Narrative

Most newcomers to creative writing place far too much emphasis on the narrative, but for a book to be a good read, the balance between narrative and dialogue has to be just right.

Too much narrative and the story will be sluggish; your reader will be bored and may even abandon the book before getting in too deep.

Conversely, too much dialogue and the pace of your book will be so fast that even the most avid of consumers will find it testing. Unfortunately, there is no absolute rule for this balance. A system that seems to work well for one writer may fail hopelessly for the next, so how do you determine the right balance for you?

Find a successful author whose style you both admire and feel comfortable with, then observe the balance that they have struck. If it works for them, the chances are that it will work for you.

Count their paragraphs per page if you need to. Determine what the maximum block size of narrative is that they will entertain. Note the variations in the length of sentences and paragraphs. Do they frequently use short sentences? Mastering the application of these simple structural limits is often a very important early step towards the development of a successful style.

Can one-word sentences make a significant contribution to the text and have an appreciable impact when they are delivered?

Yes!

An enormous amount of information can be conveyed through dialogue and this should not be forgotten.

"That bread smells delicious Ma."

The simple sentence above tells us that the person being addressed is a good cook who bakes her own bread. It also describes the relationship between the two characters involved and informs us that younger of the two is hungry and likes their mother's cooking. It would not be easy to say all that with just five words of narrative.

Avoid Repetition and Reiteration

Be wary of repeating phrases, principally in opening lines, and don't give your readers the same piece of information twice.

However tempting it might be to push a point home, perhaps by rephrasing it or delivering it in some other way, don't do it!

It is best to avoid reiteration. Repeating information is not particularly complimentary to your reader and they will not thank you for it.

Say it well. Say it once!

Essays and Reports

Whenever a writer is faced with a blank sheet, having a good plan will always get them off to a good start. This applies to virtually all forms of written work, not just those that fall into the category of creative writing. A good tip for writing non-creative texts is to open your work with a background discussion of the basic subject, introducing your reader to the bigger picture before getting down to the specific details.

Now, think of the main point that you want to bring home in your essay, or the problem that you are investigating in your report, but don't reveal any secrets yet! Instead you should explain how this problem impacts on your chosen subject, to set up a sense of expectation.

Once the tension has been established, it is time to reveal your objective; to outline the ideal anticipated conclusion of your document.

At this point you should tell your reader something of your journey. This is really much easier than it sounds. You might begin by describing the initial direction of the research that you undertook for your essay or article. This might be the first of a series of possible solutions, offered by various authorities on the subject, that it is necessary to explore before you can make your conclusion.

Next you might point out the drawbacks of your recently investigated avenue of enquiry. Discuss the pros and cons of as many opinions or solutions as you feel necessary, in order to comprehensively cover your subject. Hold back on one common drawback and your prime solution though, you will need them later.

What is it that all of these resolutions fail to address? The one problem that affects all of the opinions or solutions discussed so far, that you have been bursting to reveal, can finally be put into print.

Now it is time to play your trump card. Reveal the system, advice, opinion or solution that you have unearthed in the course of your research, or even come up with by your self. The one idea that will overcome all of the difficulties discussed so far.

Finally tie up any loose ends by justifying any remaining positive points relating to your choice of solution.

Note: You may have thought that the writing system outlined in this book is not applicable to essays and articles. However, if you have a quick look back at this chapter, you will find that it contains eight paragraphs, each of which conforms to one of the elements of the Wig or Cap formula!

Children's Story "Adam's Apple"

Foreword

Using the method outlined in the *Simple Stories* chapter, we will now apply the full nine elements of the 'Wig Or Cap' formula to a children's picture book story containing just six pages.

ACT I

Page 1 - World

Adam was a grub who lived in an apple.

Page 2 - Imbalance and Goal

Every day Adam grew bigger and every day his apple got smaller, until one day, Adam realised that he would have to leave the apple and look for a new life.

ACT II

Page 3 - Obstacle and Resolution

The trouble was, Adam had no arms and legs to climb down the tree, and all that eating had made him tired. Very wisely, Adam decided to have a sleep before he left.

ACT III

Page 4 - Complication

While Adam was asleep his skin turned into a shell and when he woke up, he couldn't get out.

Page 5 - Attainment

Adam kicked and he stretched and he wriggled until his shell split, and when he stepped out he couldn't believe his eyes. Adam had turned into a beautiful moth with brightly coloured wings.

Page 6 - Parcel and Hook

Now Adam was able to leave the tree and fly off into the night to search for a new home and a new friend to share it with.

Note about the Hook

The reader may be left wondering, how is Adam getting on with his search for a new life? This provides an opening for the first sequel, "The Adventures of A. Moth".

Comedy Film "Rat Race"

Starring: John Cleese, Rowan Atkinson and Whoopi Goldberg

Foreword

This particular film was chosen to demonstrate the wide variety of structures that can be used for story telling. It is particularly unusual in having multiple heroes with a single goal.

Despite this unconventional approach, it should be noted that this film format still conforms precisely to the Wig Or Cap formula.

ACT I

World

Several characters arrive at a Hotel Casino in Las Vegas for fun break. Each character, or set of characters, has a different purpose for being there. One has brought his family but is intent on winning his fortune in order to solve his problems. Another rather dull character is about to return to his usual boring world and two others are there for a reunion.

These characters are quickly introduced, each in turn, and are destined to become the heroes or protagonists of the tale.

Imbalance

Each of the characters unexpectedly wins a gold coin, which turns out to be an invitation to drop what they are doing and attend an unexpected social gathering organised by the management.

Life in their independent worlds is suddenly and mysteriously interrupted.

Goal

Here the purpose of the gathering is revealed. The hotel manager, one of the richest men in the world, has placed two million dollars in a case in a locker in a far off town. They are each given a key to the locker and told that whoever gets there first keeps the money.

The true purpose of the race is to provide entertainment for a group of wealthy compulsive gamblers who wish to bet on the outcome.

Unhappy with their lot, the would-be heroes all succumb to temptation and their goal is to win the race. Each one hopes to return to their own world far wealthier, and therefore in a position to resolve their personal problems.

ACT II

Obstacle

There are many obstacles encountered by each of the unlikely heroes in their attempt to get to the money.

Some of the problems encountered along the way are introduced through pure bad luck; some by competition with other characters and some problems are simply introduced as a result of the incompetence of the characters themselves.

Resolution

Each obstacle is overcome, sometimes by resourcefulness and sometimes by sheer good fortune, as all of the heroes gradually get closer to their objective.

ACT III

Complication

At the last moment, just as the money is about to be claimed, the villain's helper and his newly acquired accomplice run off with the loot. The chase that follows culminates when the money is lowered from a hot air balloon onto the stage at a benefit gig for the world's most underprivileged children.

Attainment

The characters, by now having agreed to share the money, arrive at the auditorium and step on stage to claim their money. Gradually it dawns on them that the lead singer, and the audience, think that they have arrived to donate their winnings to the cause. As one by one they see the light and happily put their money into the sack provided, we begin to realise that the moral of the tale is: It is better to give than to receive.

Parcel

In contrast to the happiness of the heroes, the villain shows his displeasure when he is shamed by one of the heroes into matching the total sum of money raised by the concert. This both ties up the loose ends and further reinforces the moral of the tale.

That's all folks! Hopefully it is not too much to remember, but enough to inspire your next big blockbuster.

www.ingramcontent.com/pod-product-compliance
Lightning Source LLC
Chambersburg PA
CBHW072300170526
45158CB00003BA/1121